the pin-up art of
ARCHIE DICKENS
VOLUME TWO

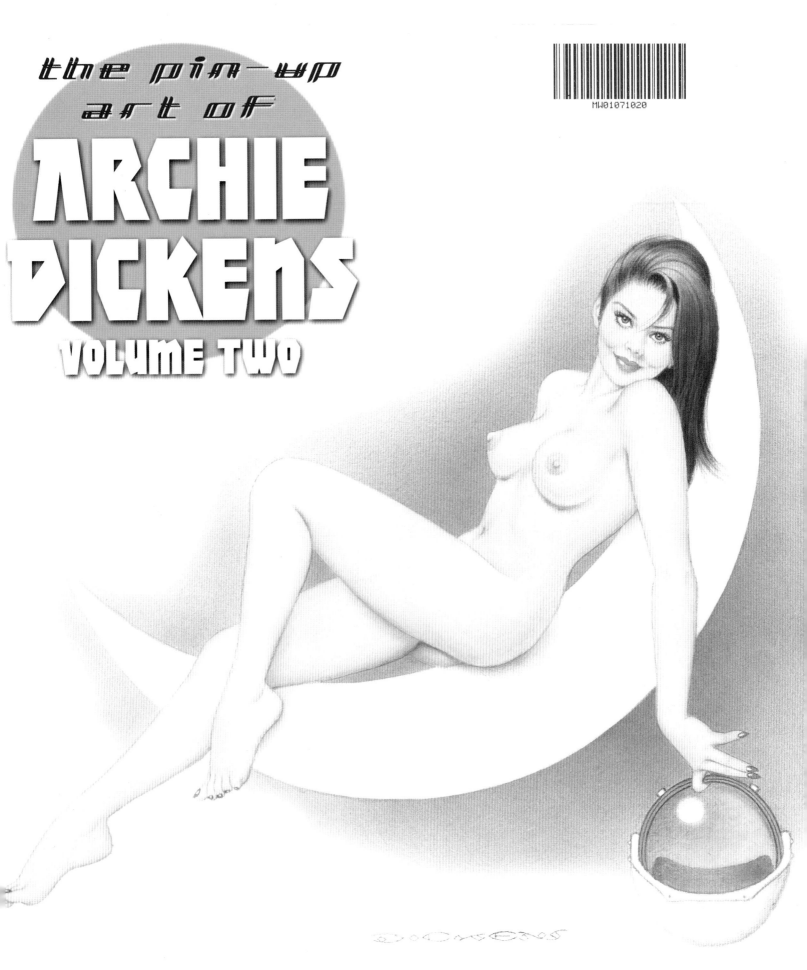

AN SQP PRESENTATION

MW01071020

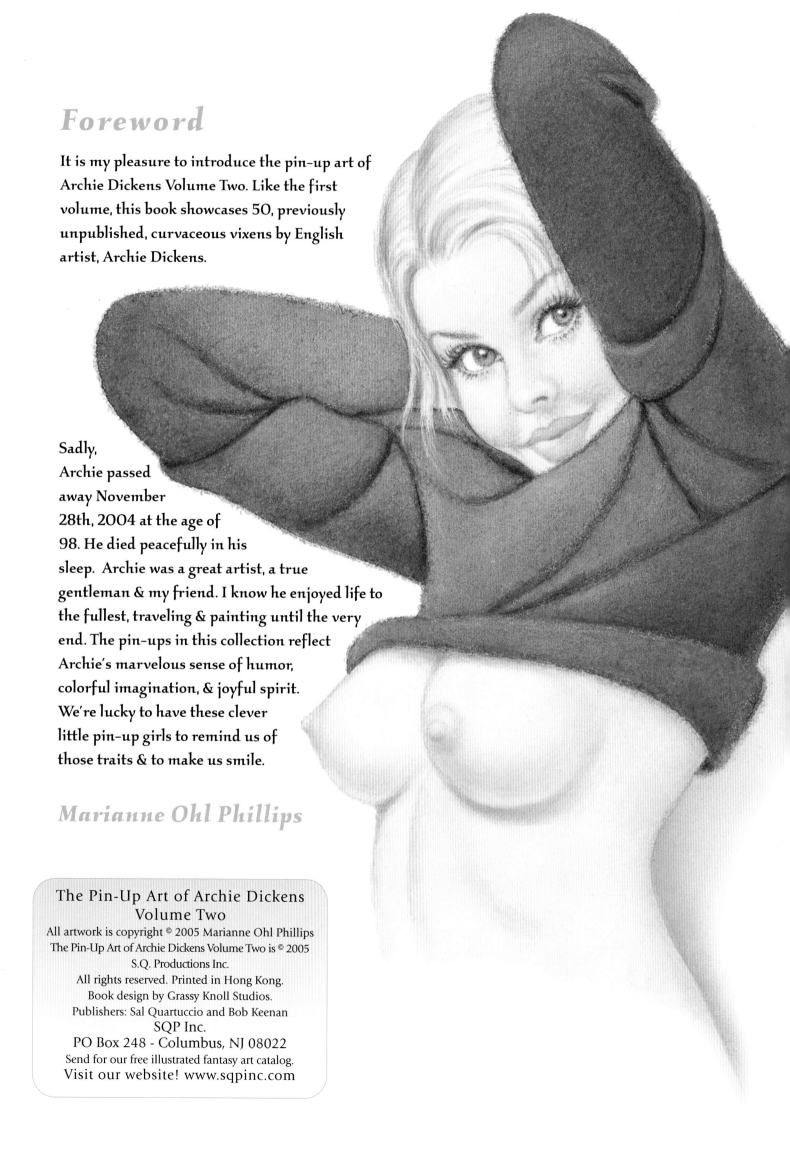

Foreword

It is my pleasure to introduce the pin-up art of Archie Dickens Volume Two. Like the first volume, this book showcases 50, previously unpublished, curvaceous vixens by English artist, Archie Dickens.

Sadly, Archie passed away November 28th, 2004 at the age of 98. He died peacefully in his sleep. Archie was a great artist, a true gentleman & my friend. I know he enjoyed life to the fullest, traveling & painting until the very end. The pin-ups in this collection reflect Archie's marvelous sense of humor, colorful imagination, & joyful spirit. We're lucky to have these clever little pin-up girls to remind us of those traits & to make us smile.

Marianne Ohl Phillips

The Pin-Up Art of Archie Dickens Volume Two
All artwork is copyright © 2005 Marianne Ohl Phillips
The Pin-Up Art of Archie Dickens Volume Two is © 2005
S.Q. Productions Inc.
All rights reserved. Printed in Hong Kong.
Book design by Grassy Knoll Studios.
Publishers: Sal Quartuccio and Bob Keenan
SQP Inc.
PO Box 248 - Columbus, NJ 08022
Send for our free illustrated fantasy art catalog.
Visit our website! www.sqpinc.com

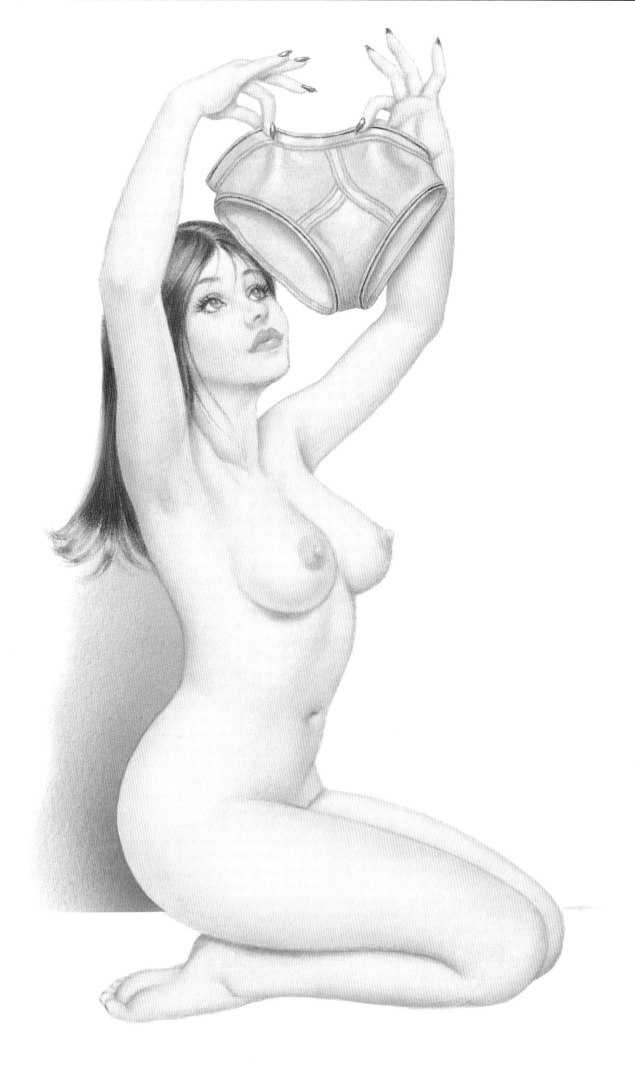

Whose Are These?

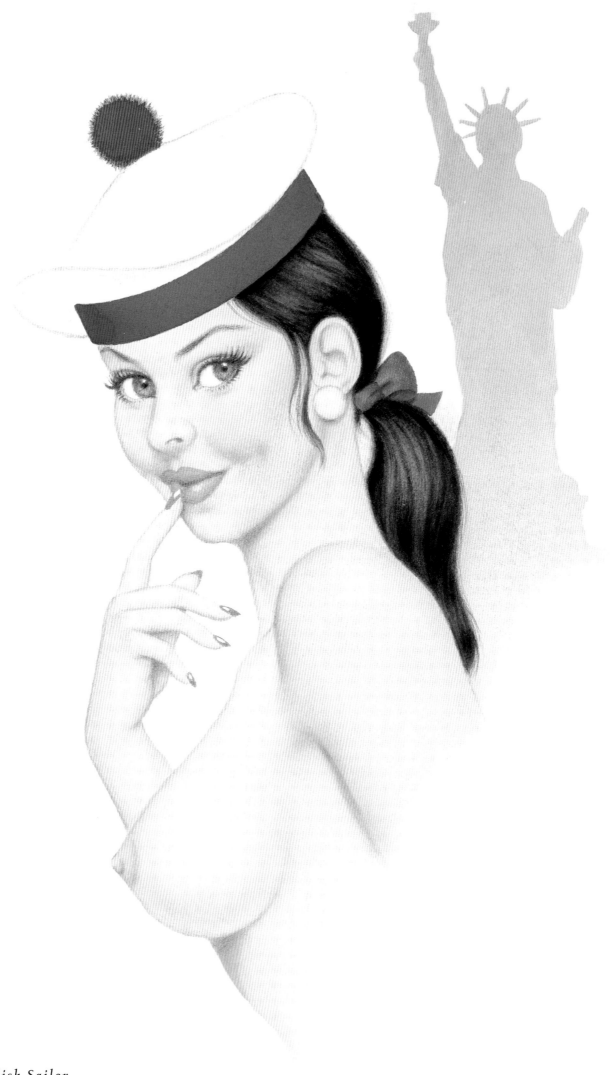

English Sailor

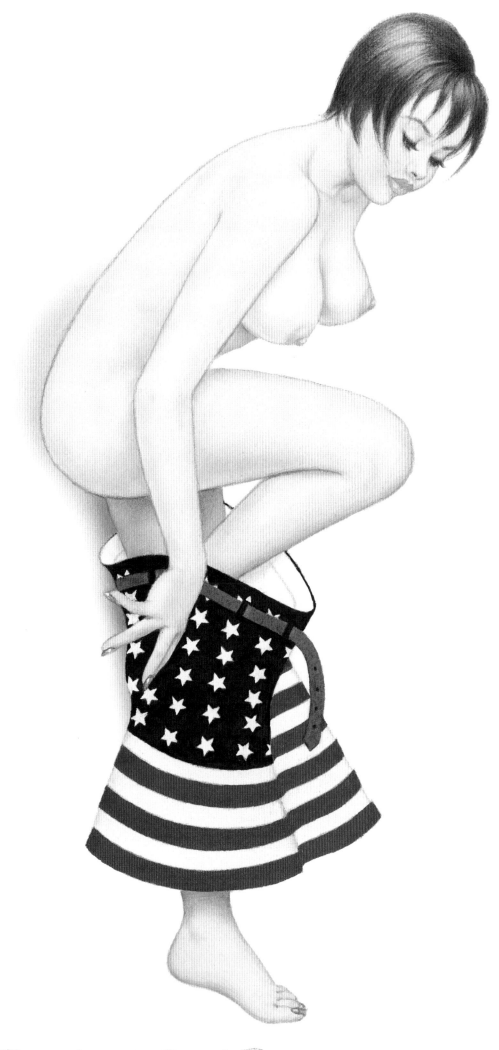

Flag Skirt

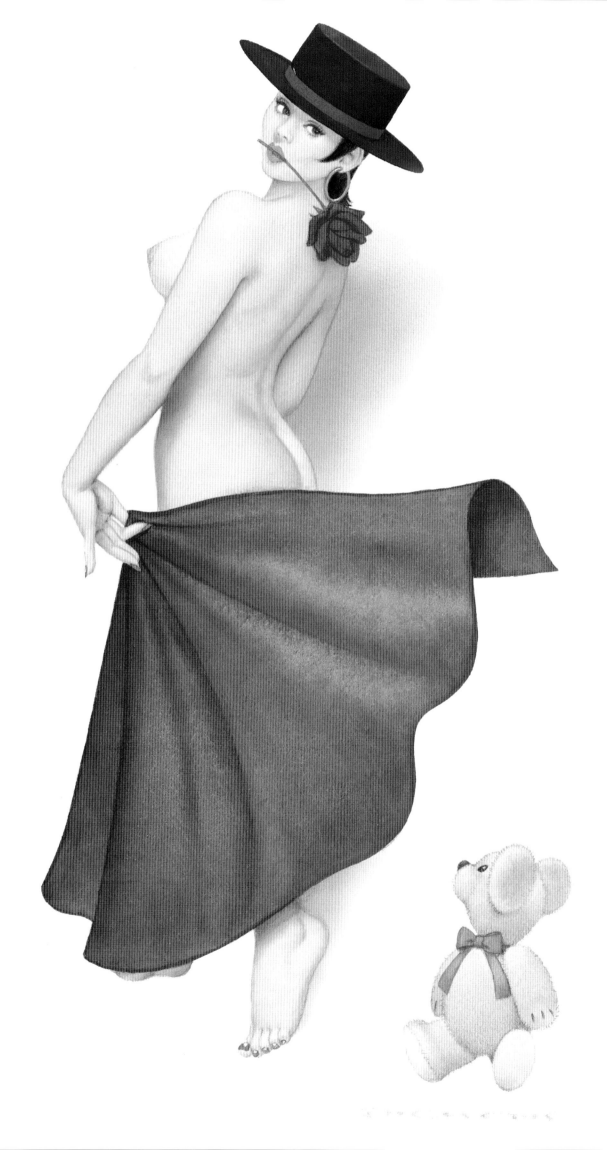

Olé!

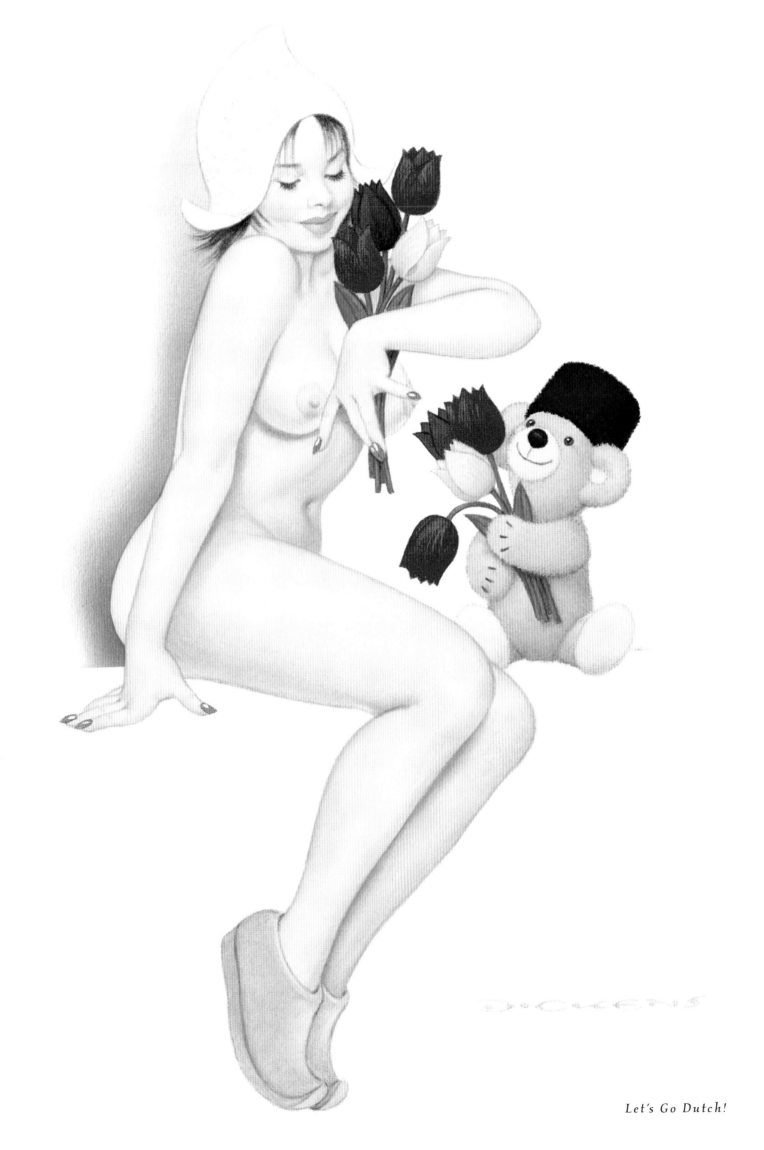

Let's Go Dutch!

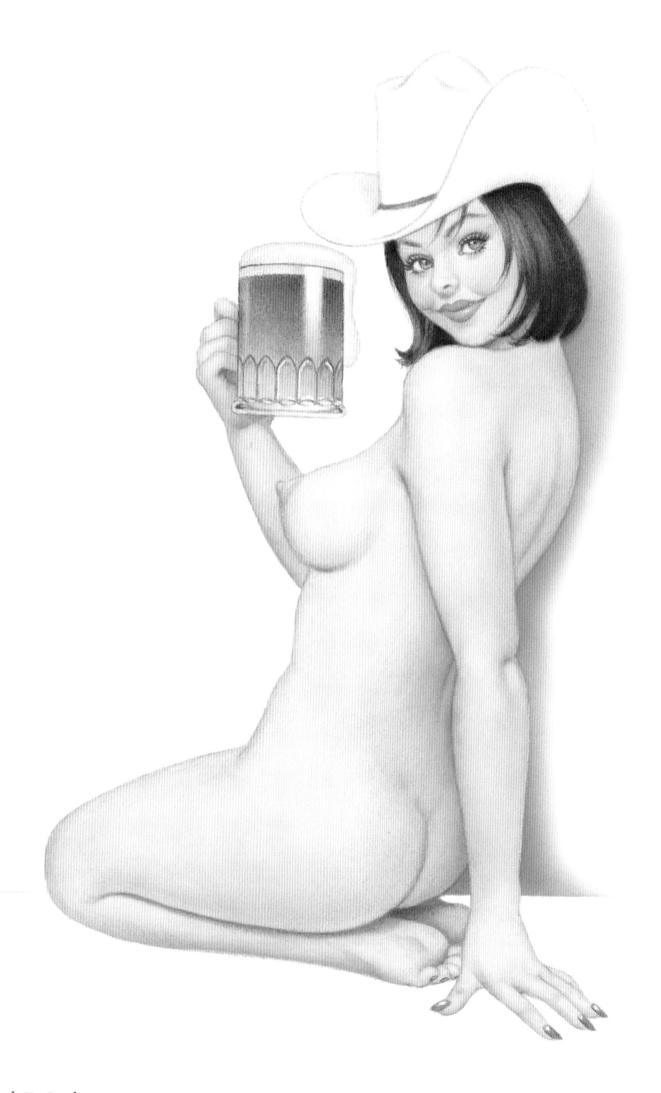

Drink Up Pardner!

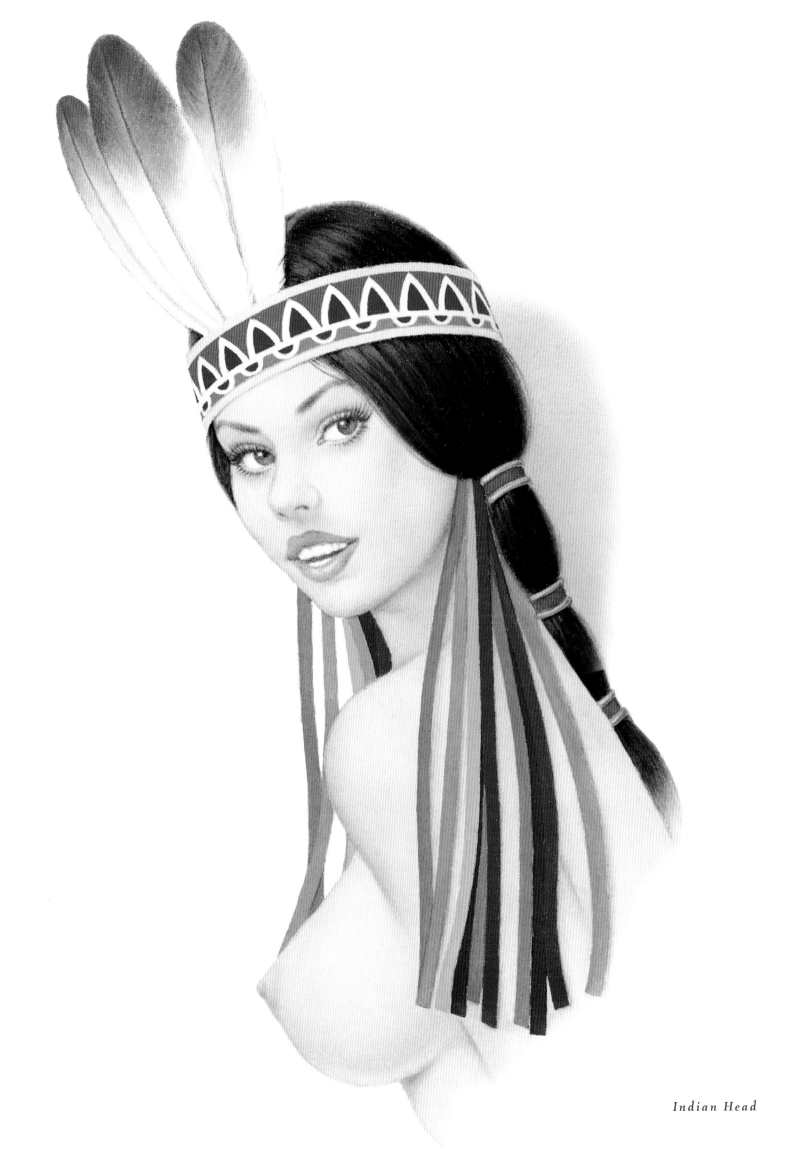

Indian Head

DICKENS

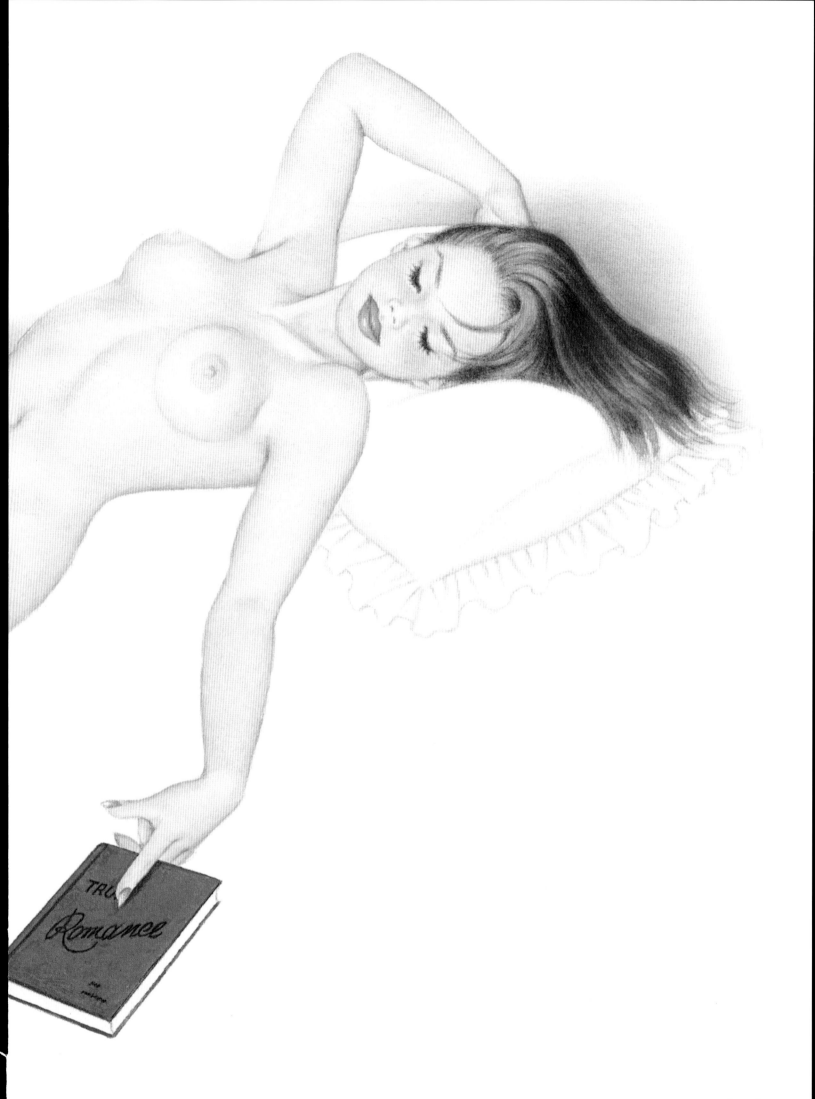

If Only

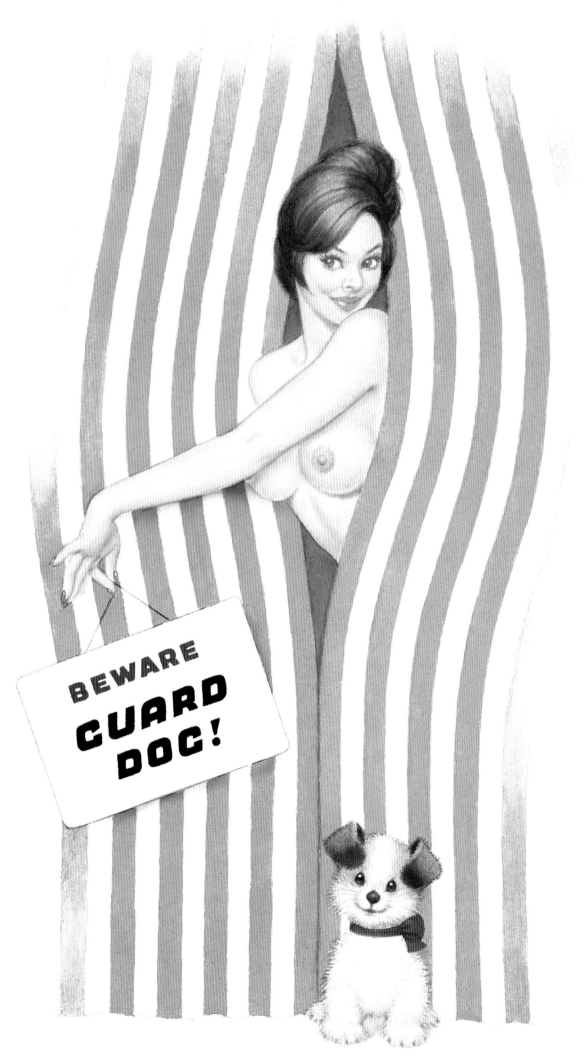

Cabana

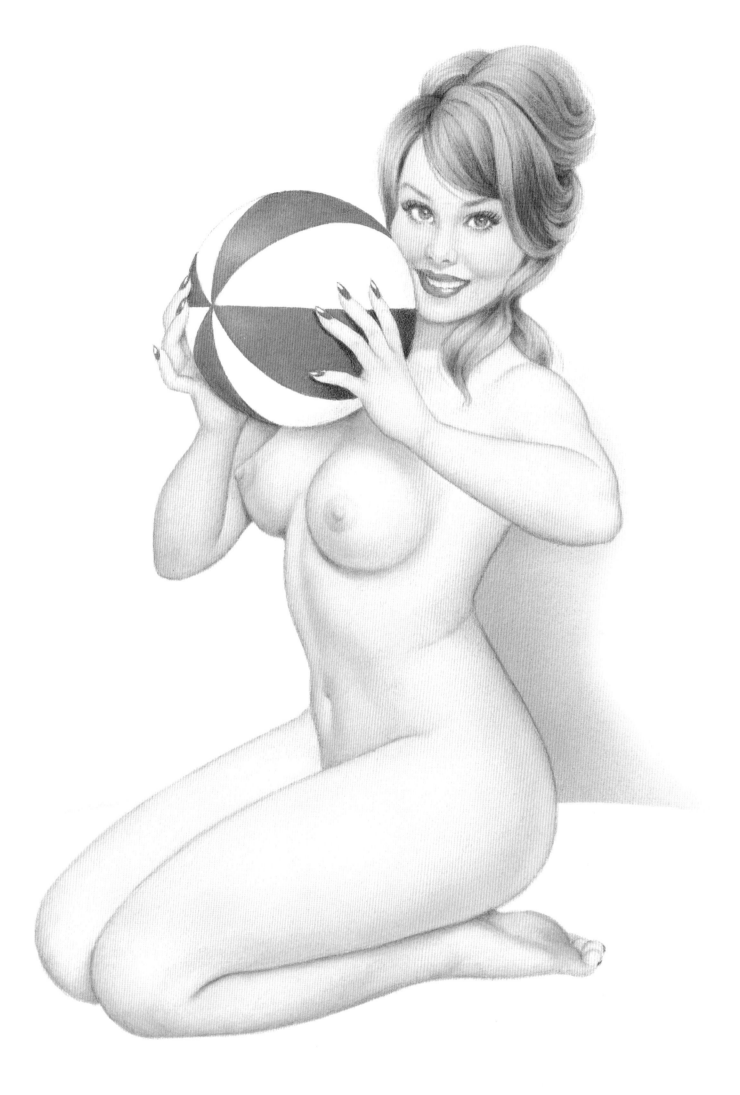

Beach Ball

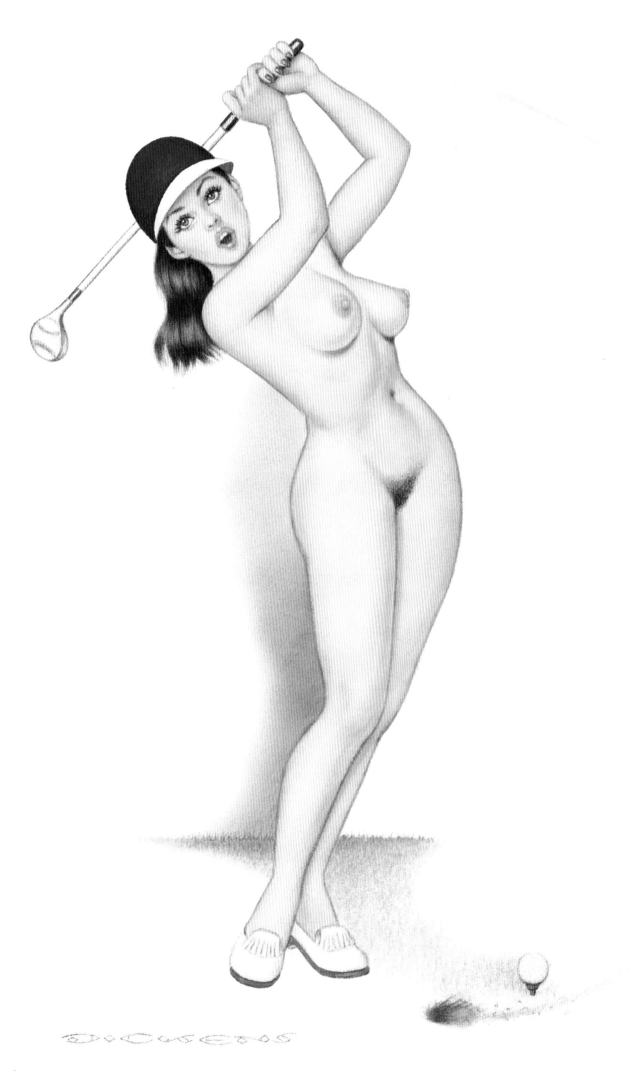

Turf In One

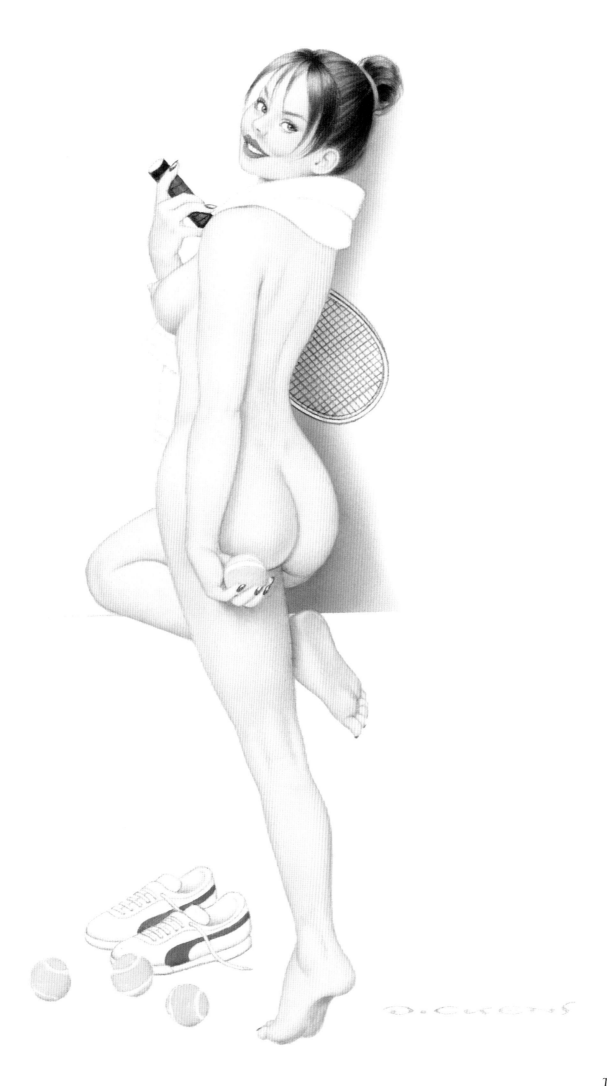

Tennis

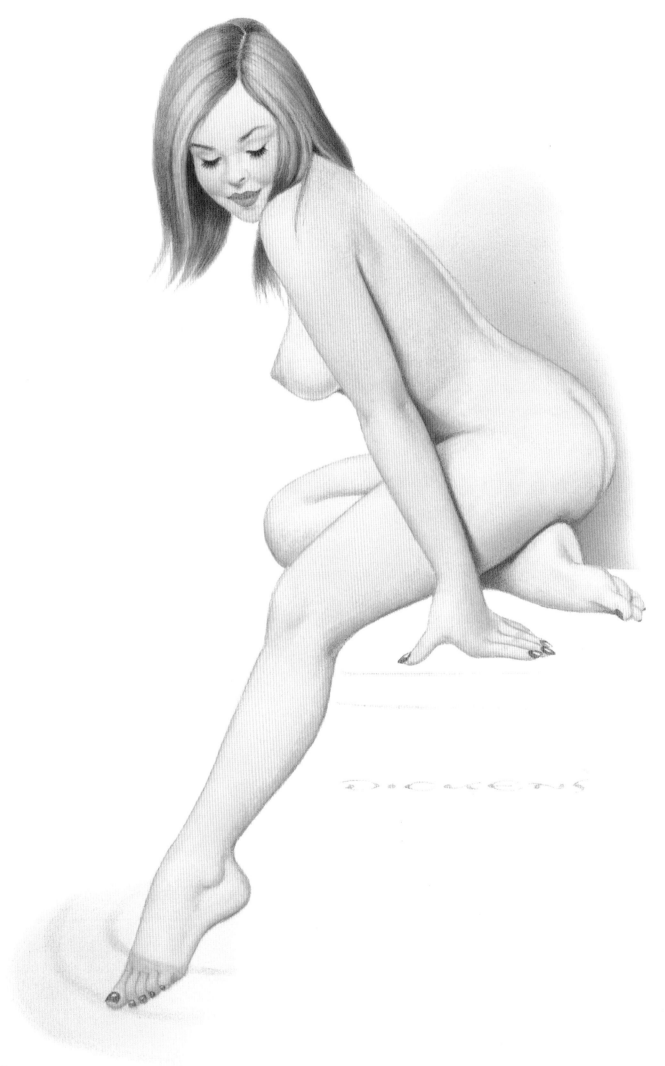

Wading

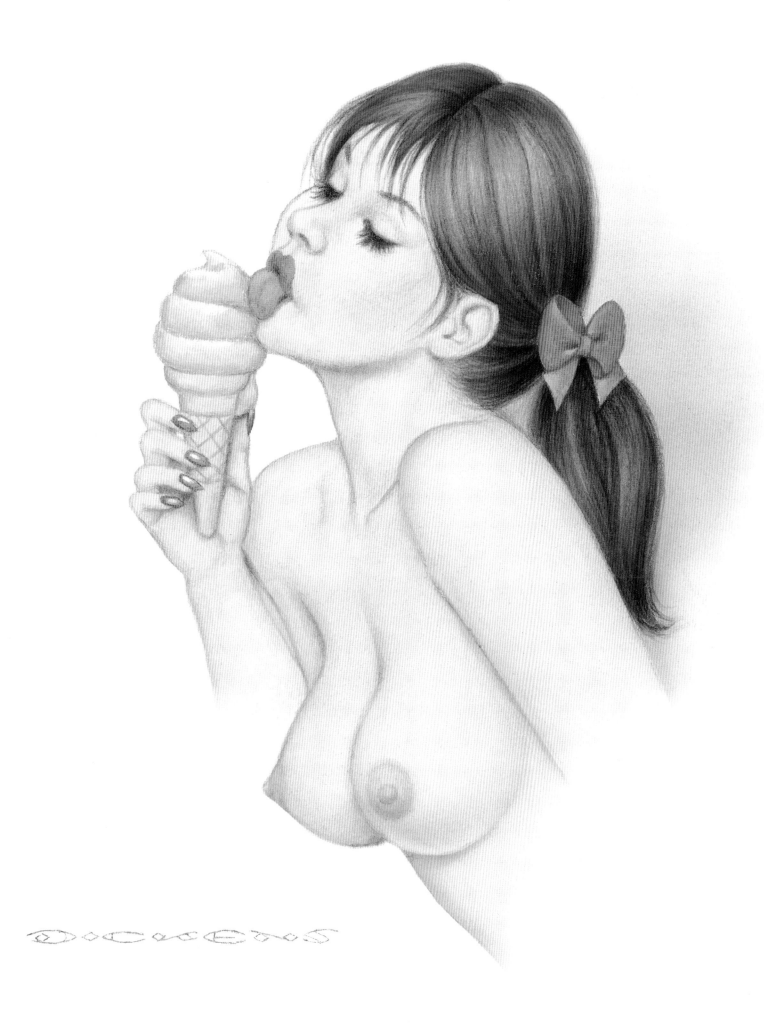

DICKENS

Just A Lick!

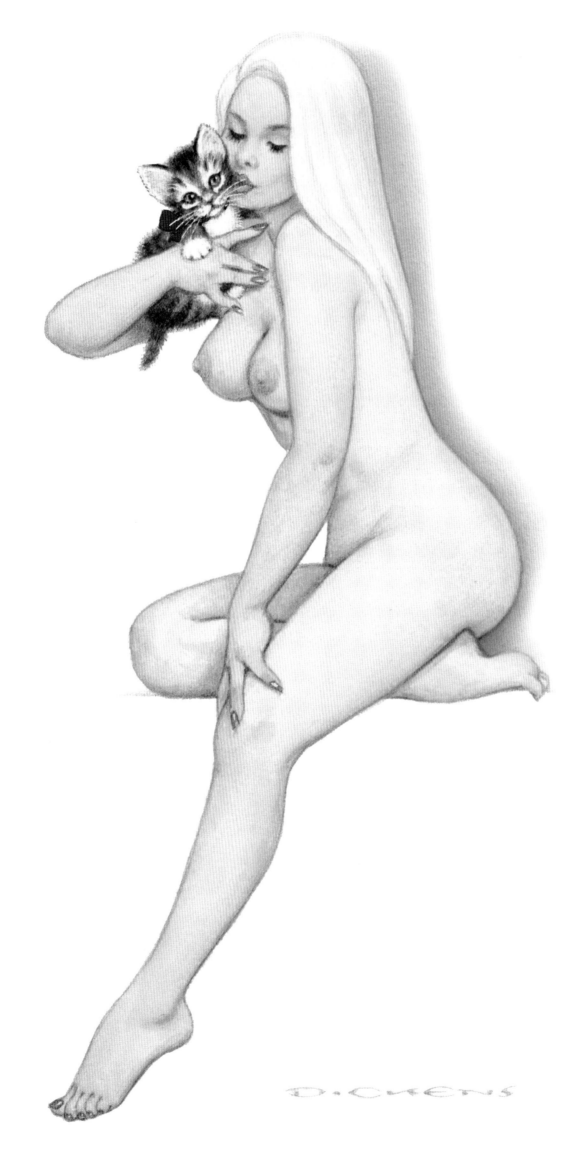

Kitty

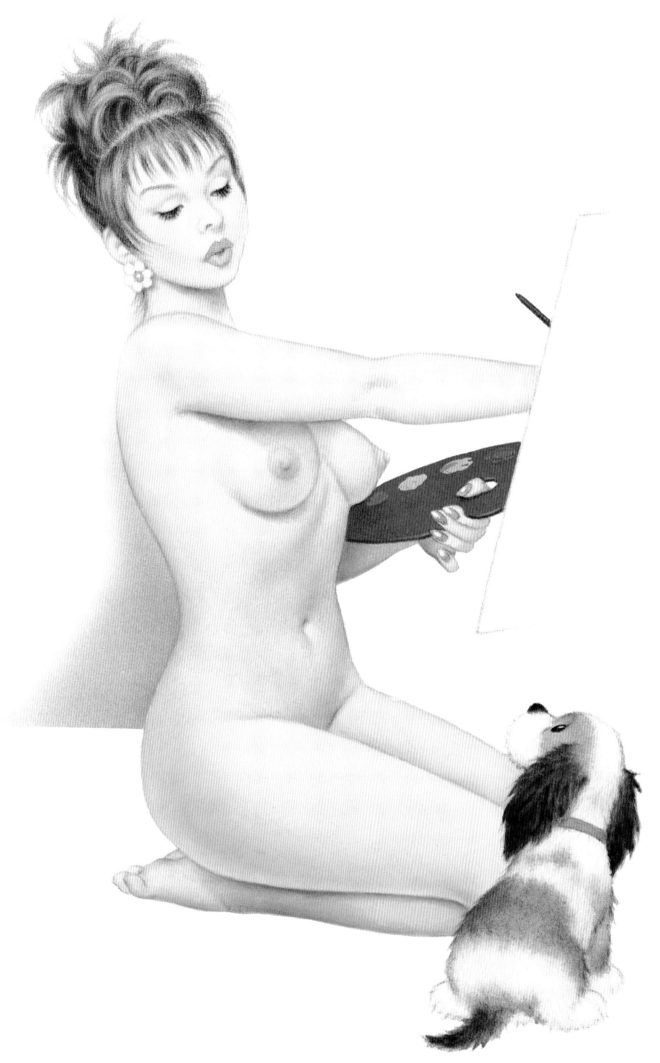

Last Sitting

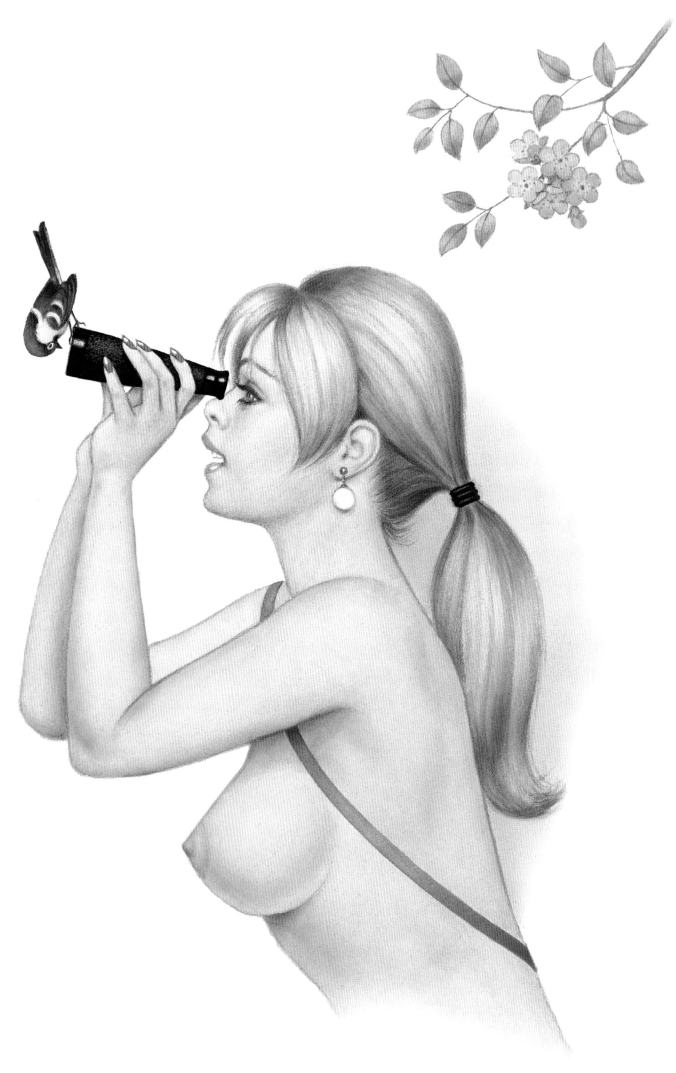

Bird Watcher

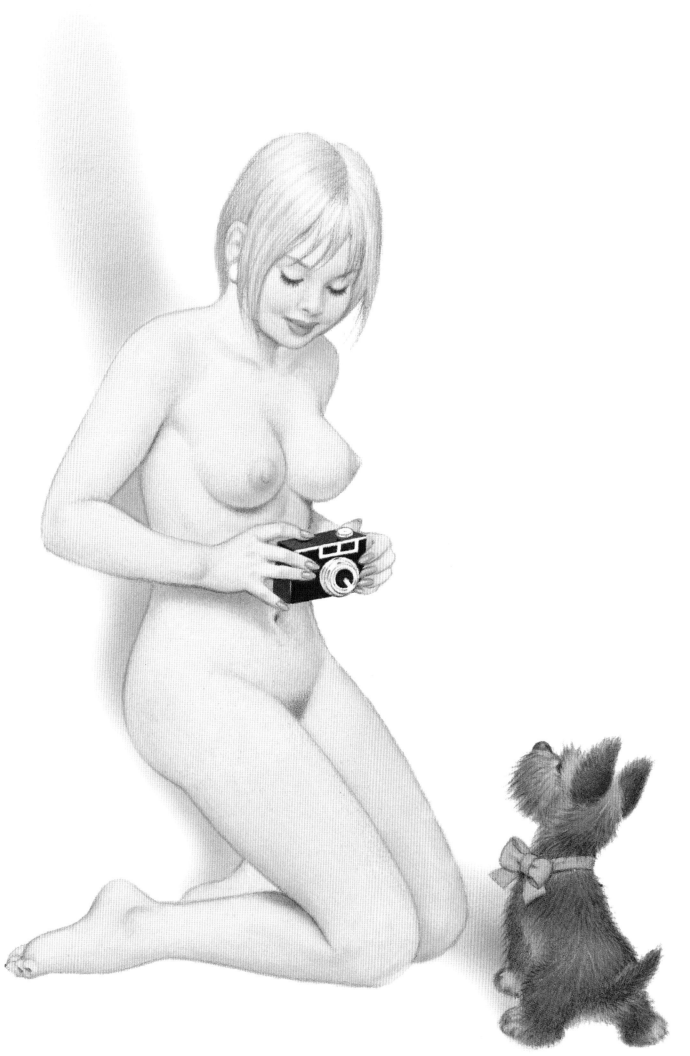

Camera Girl

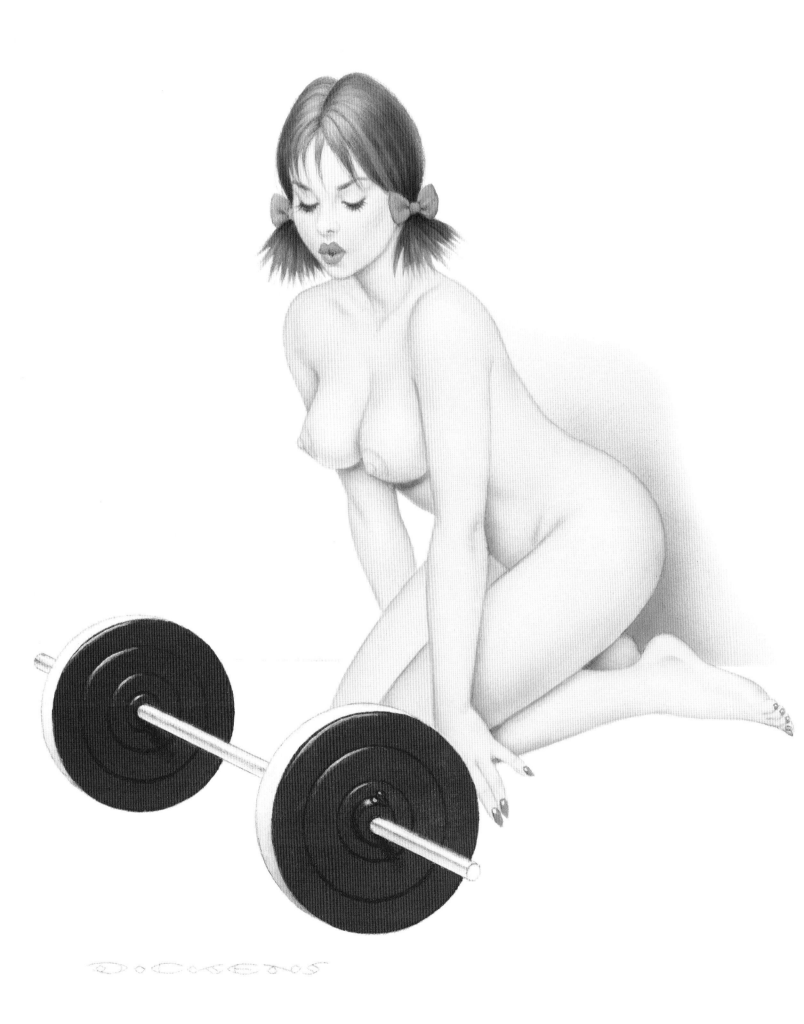

Bar Belle

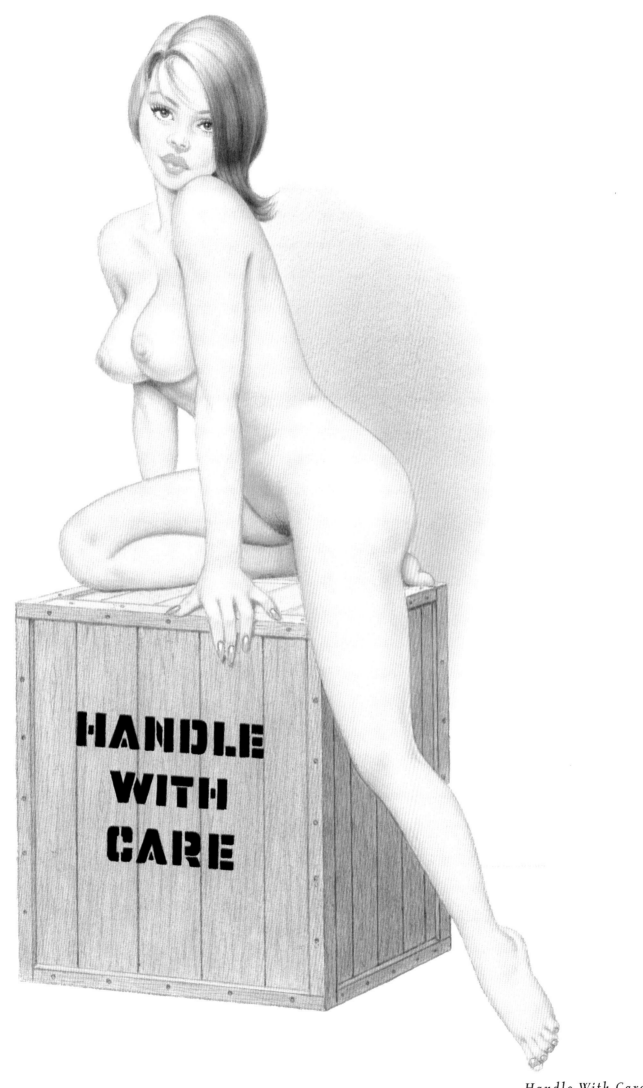

Handle With Care

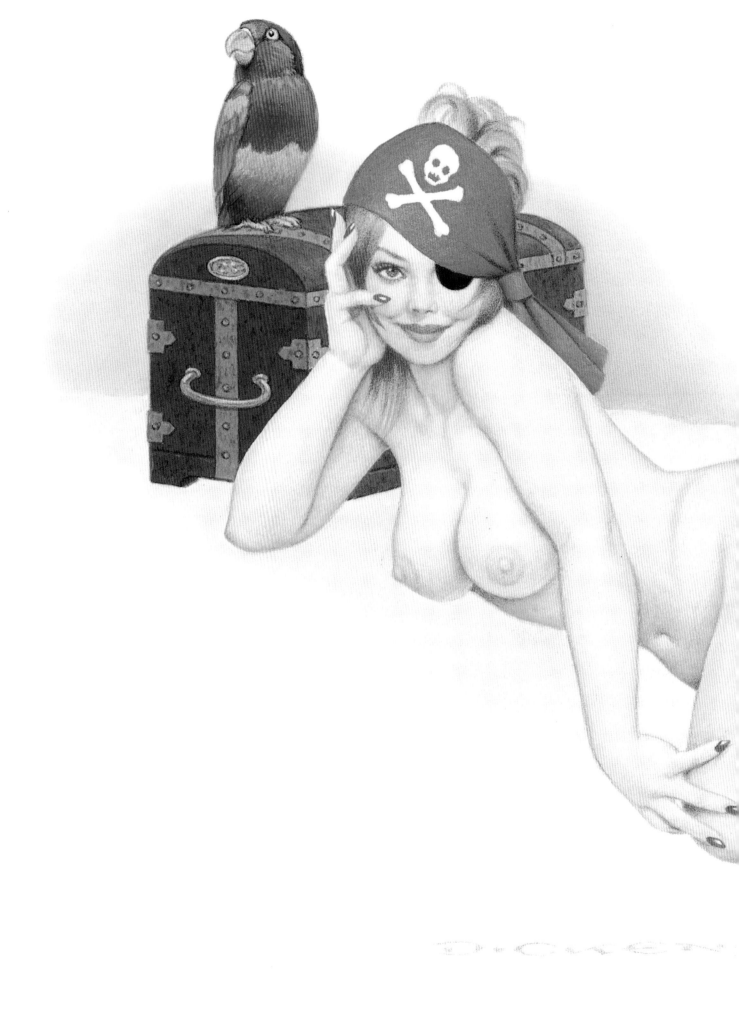

Treasured Chest!

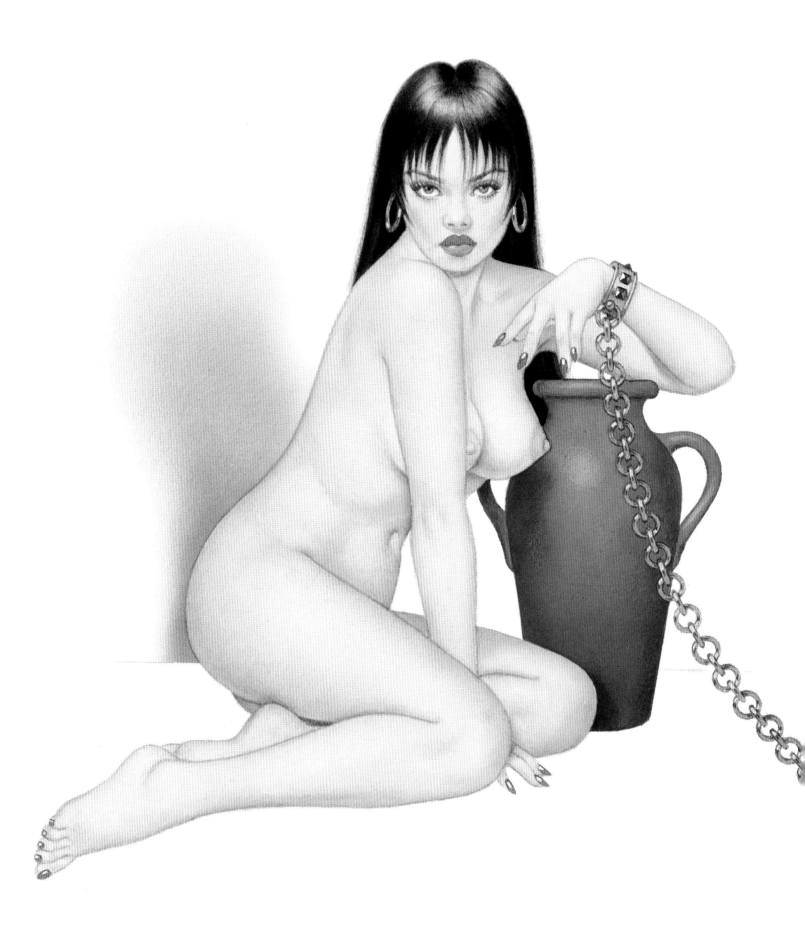

Slave Girl

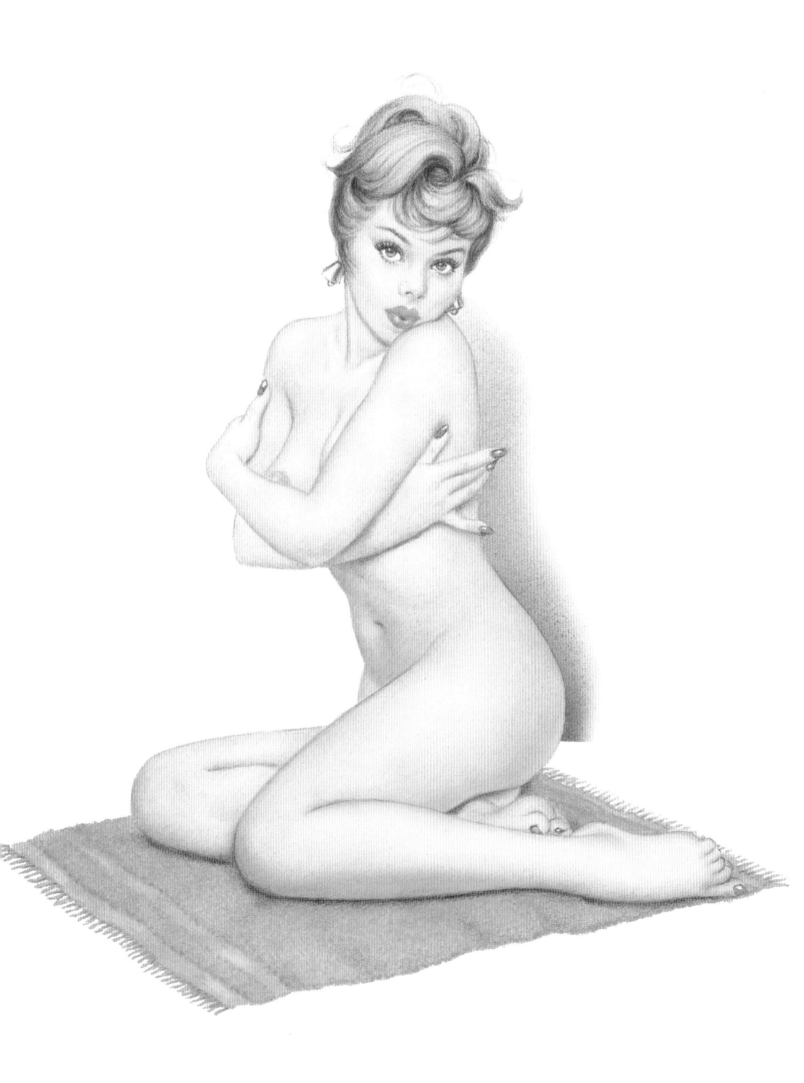

Just A Minute!

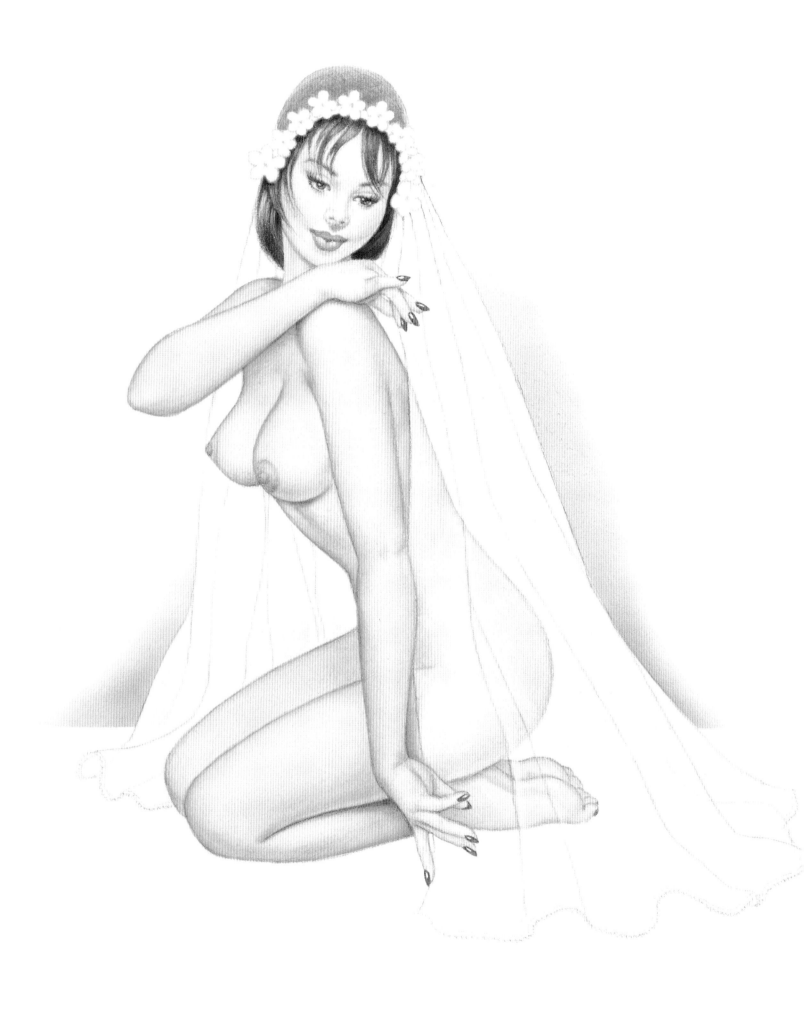

Bridal Veil

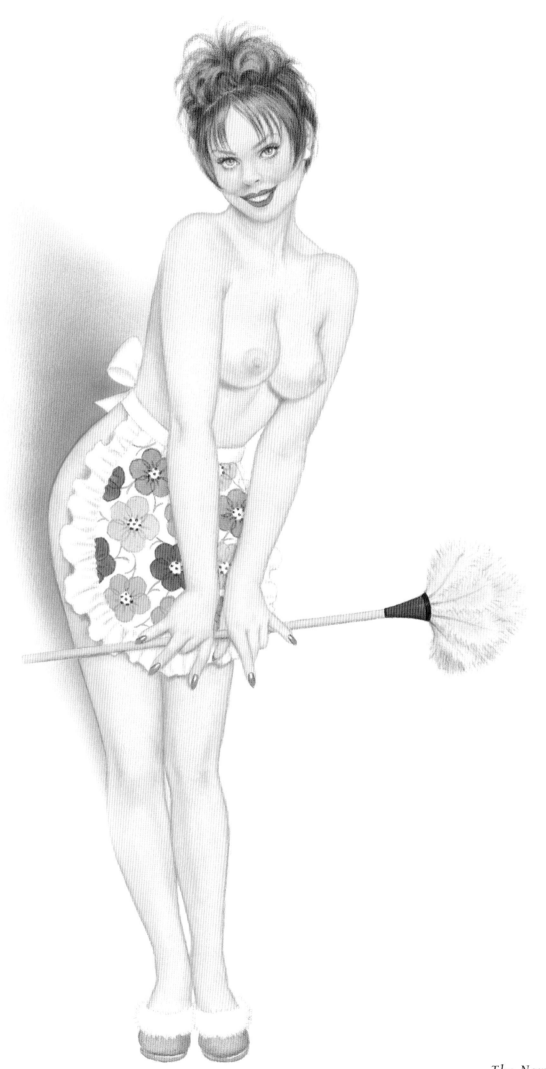

The New Aupair

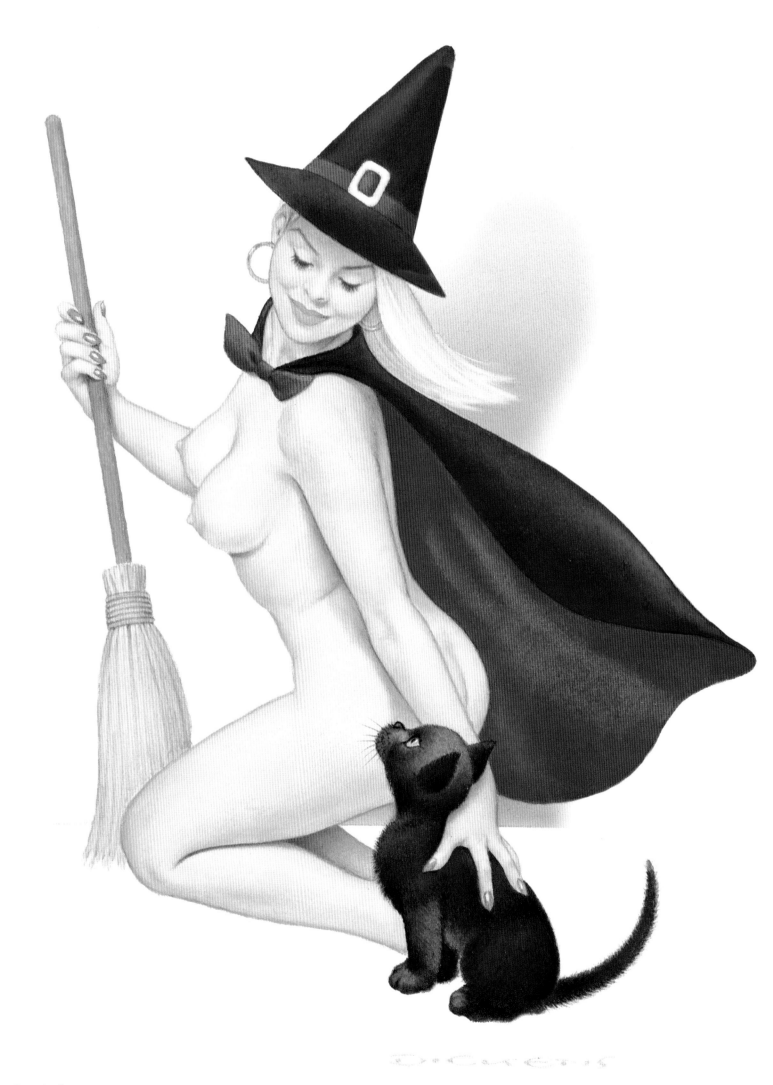

Bewitching

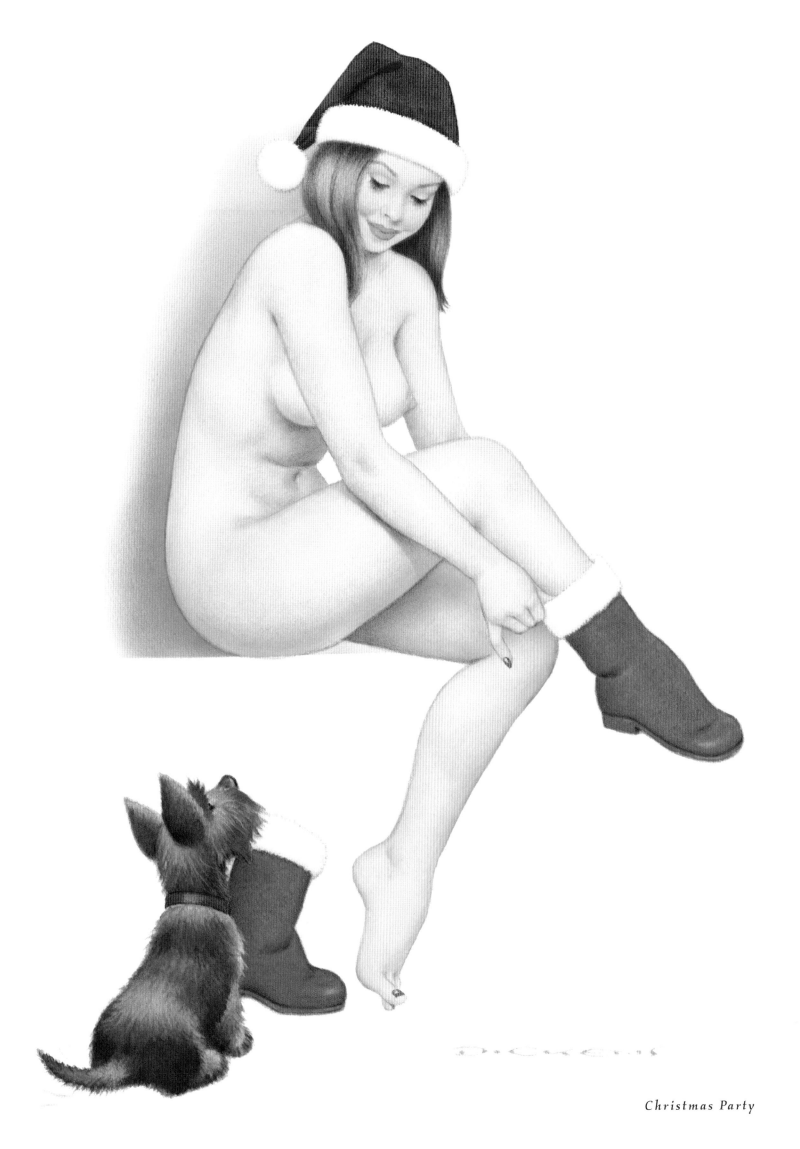

Christmas Party

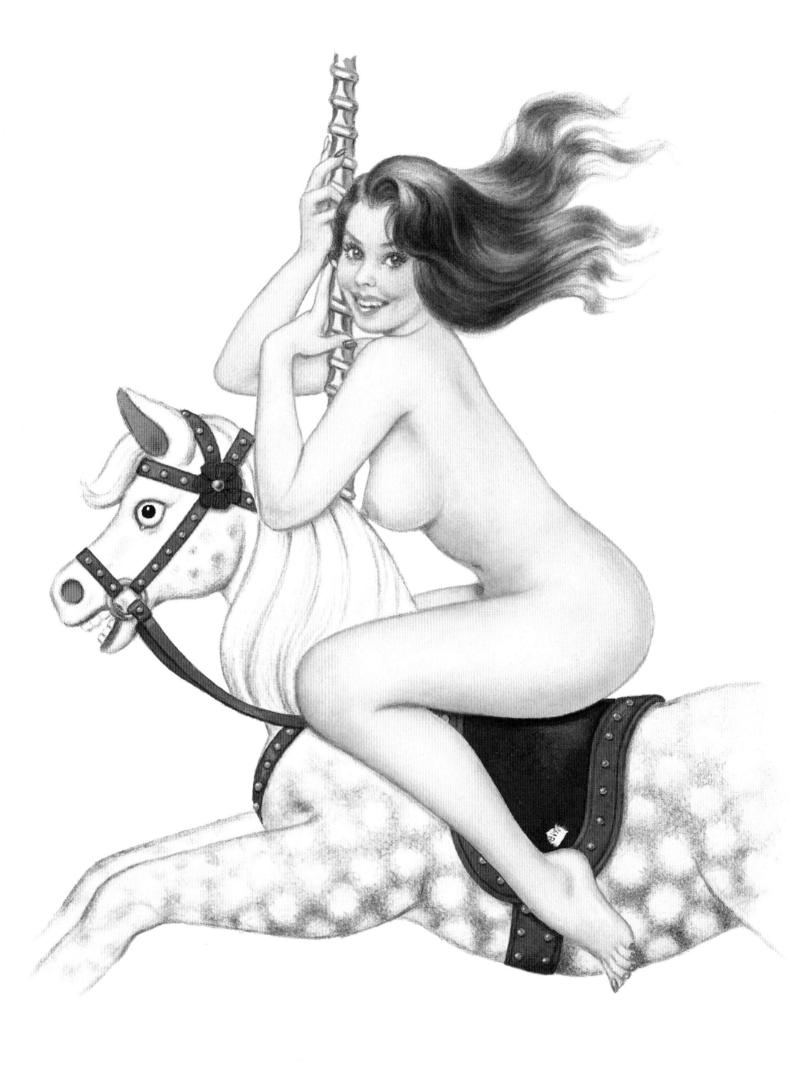

Carousel

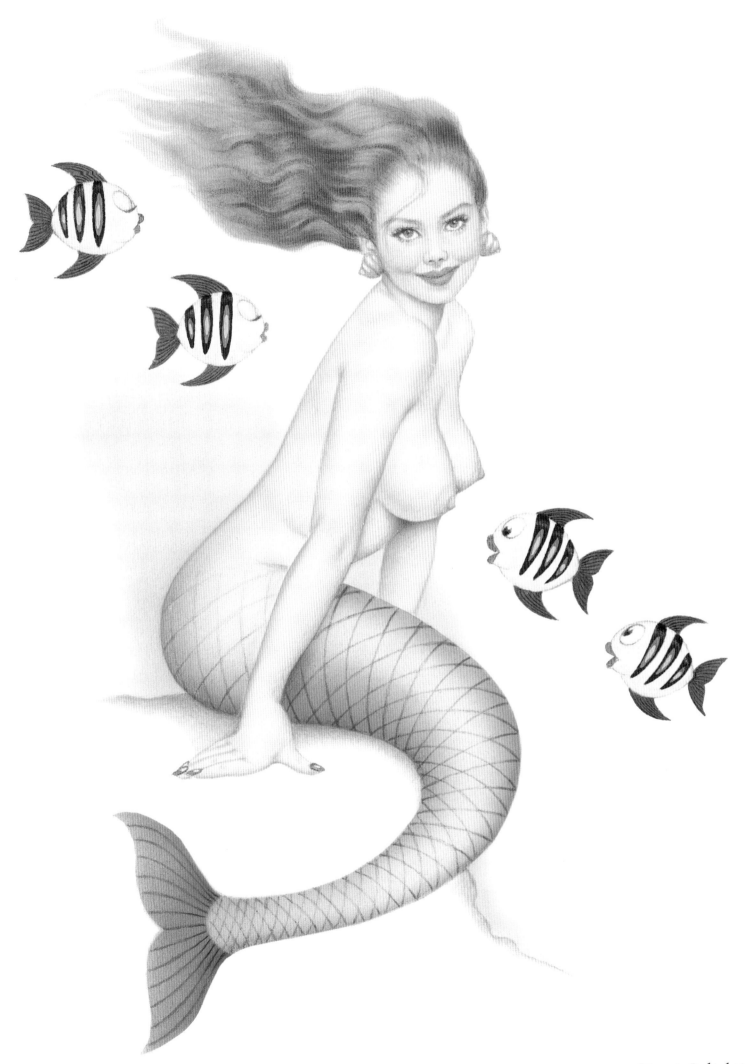

Diver's Delight!

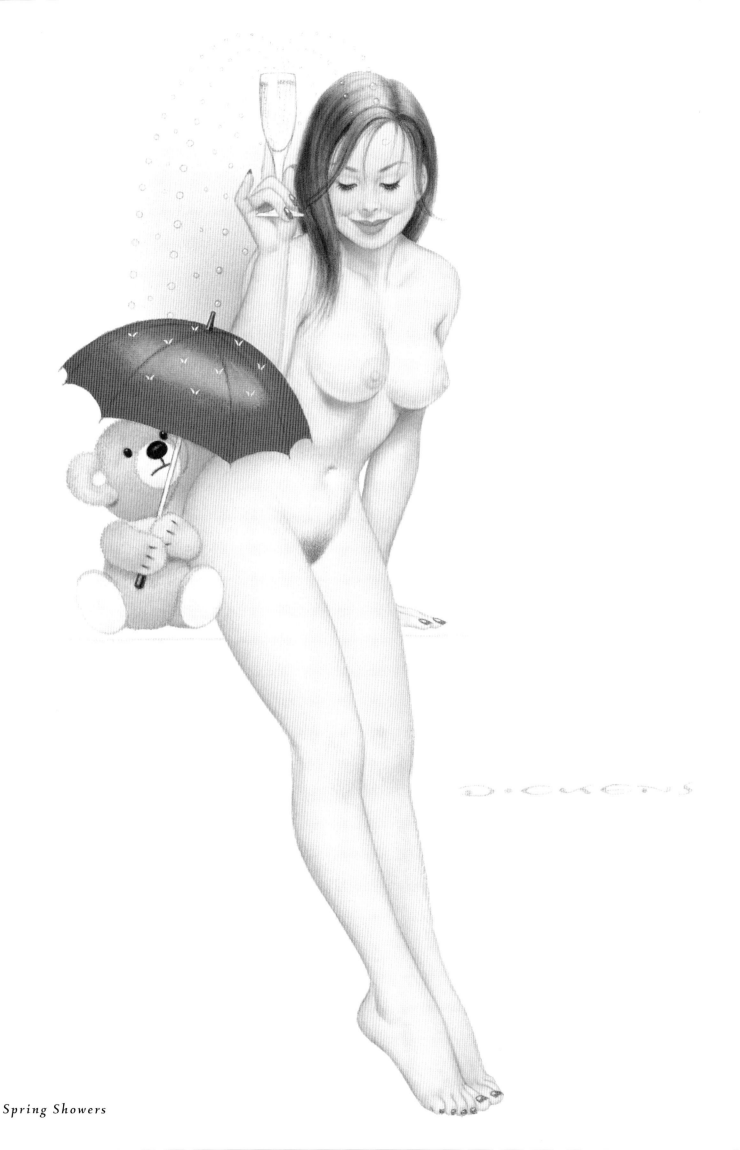

Spring Showers

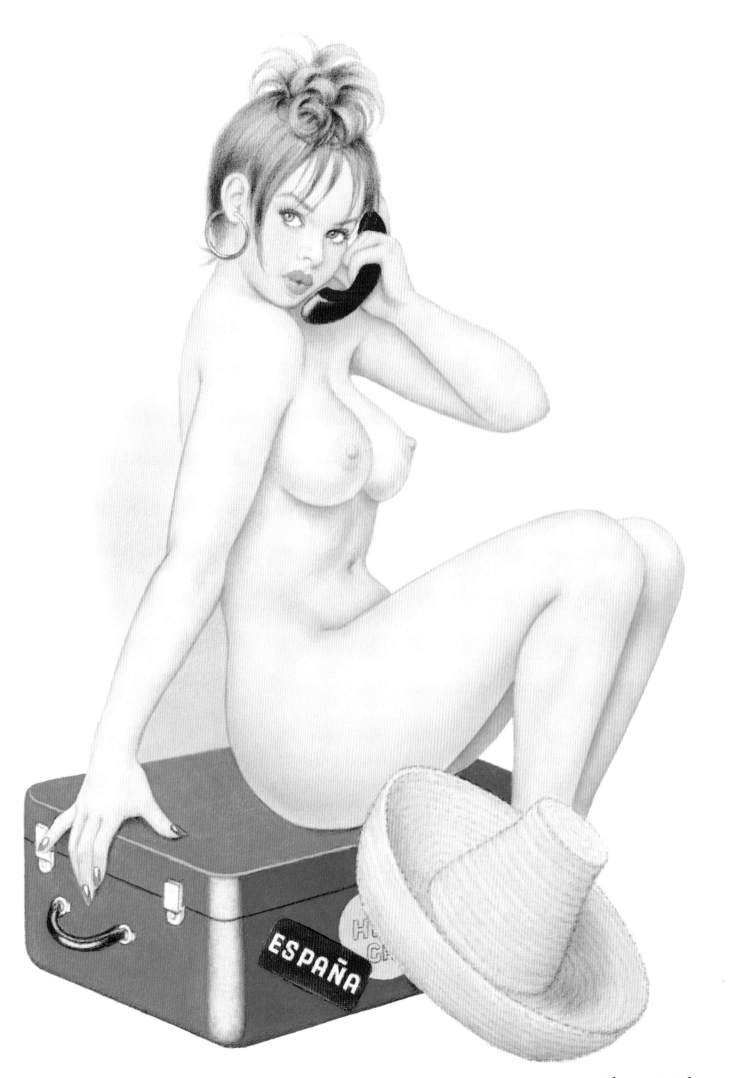

There's A Delay...

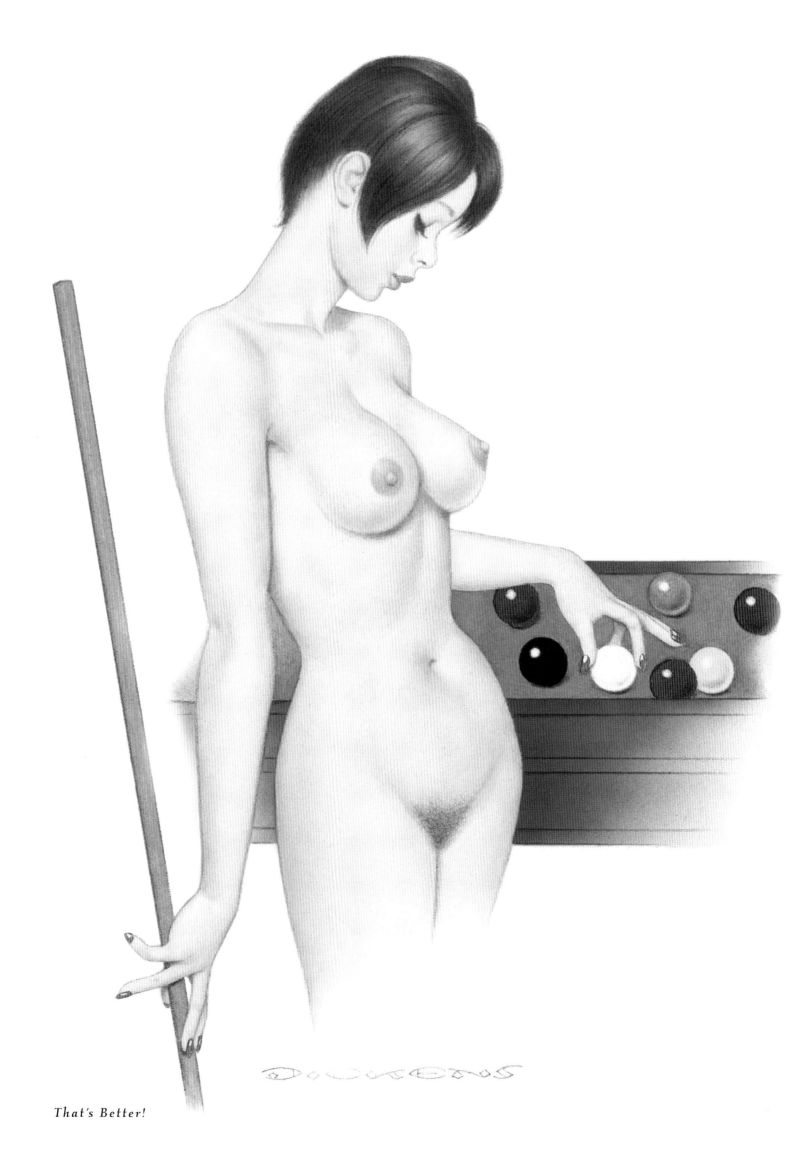

That's Better!

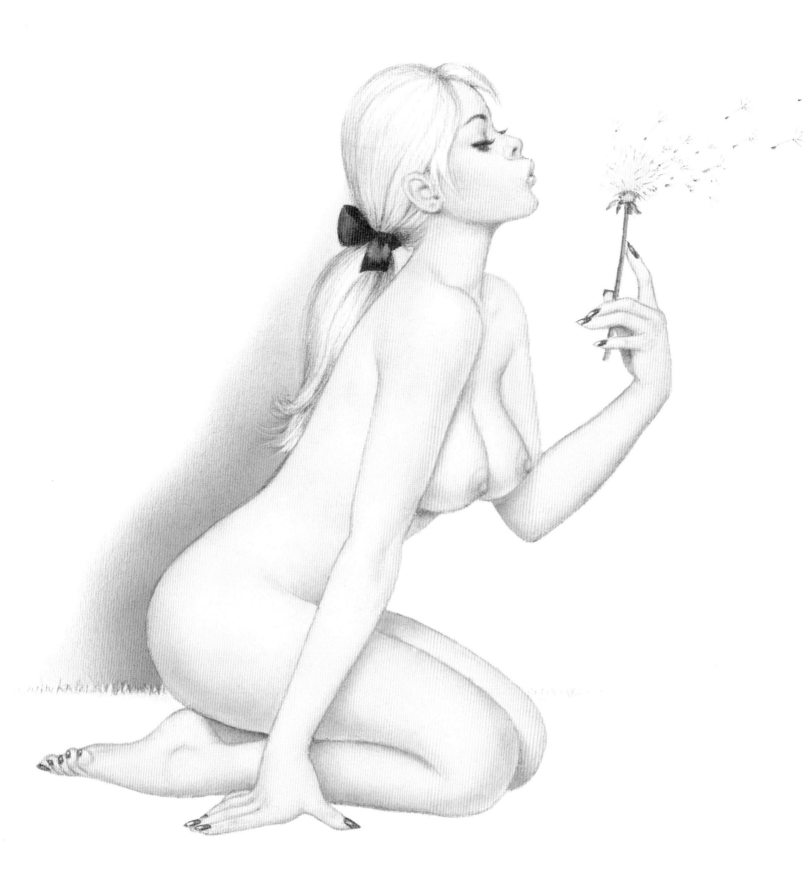

A Gentle Breeze

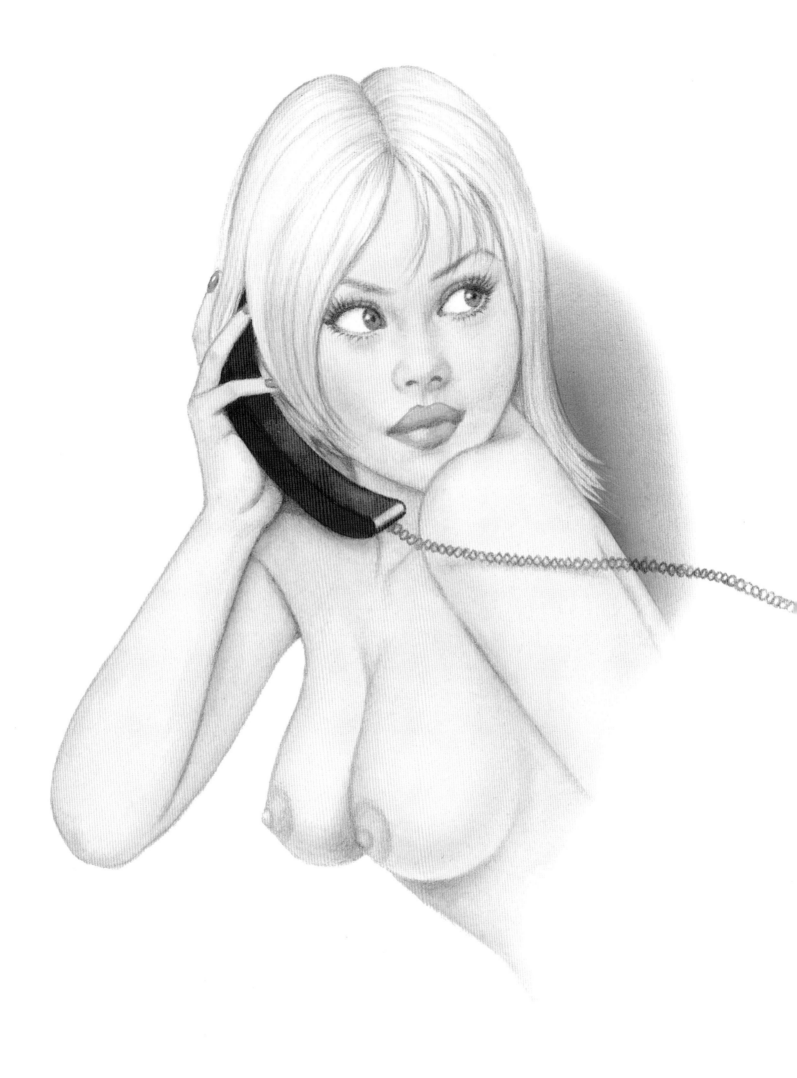

Still Busy....

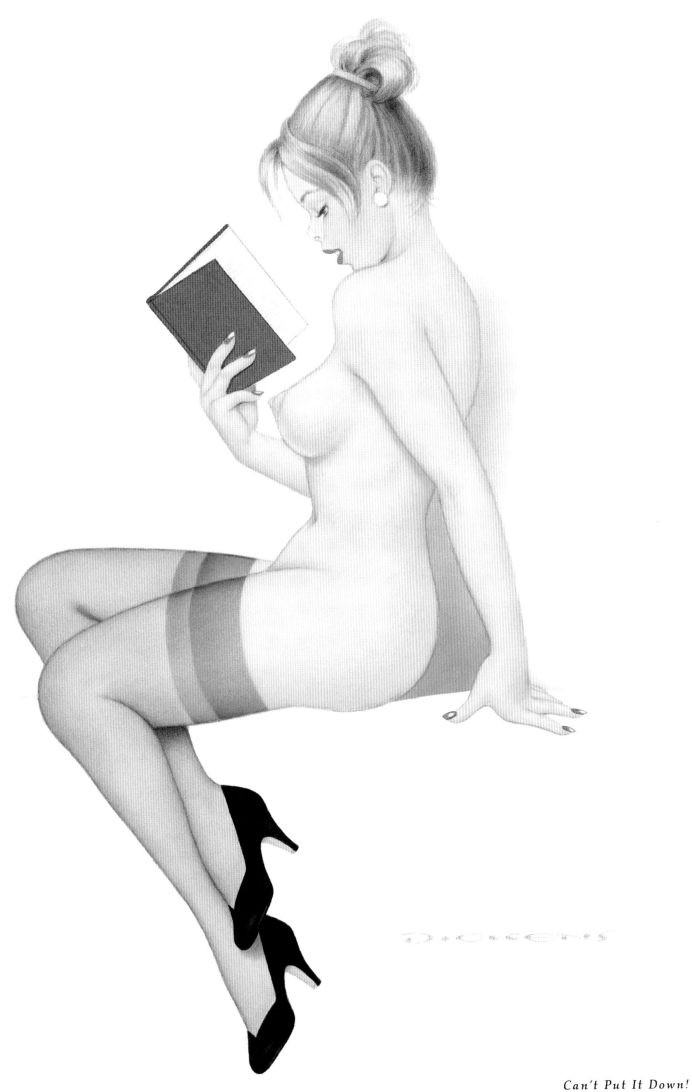

Can't Put It Down!

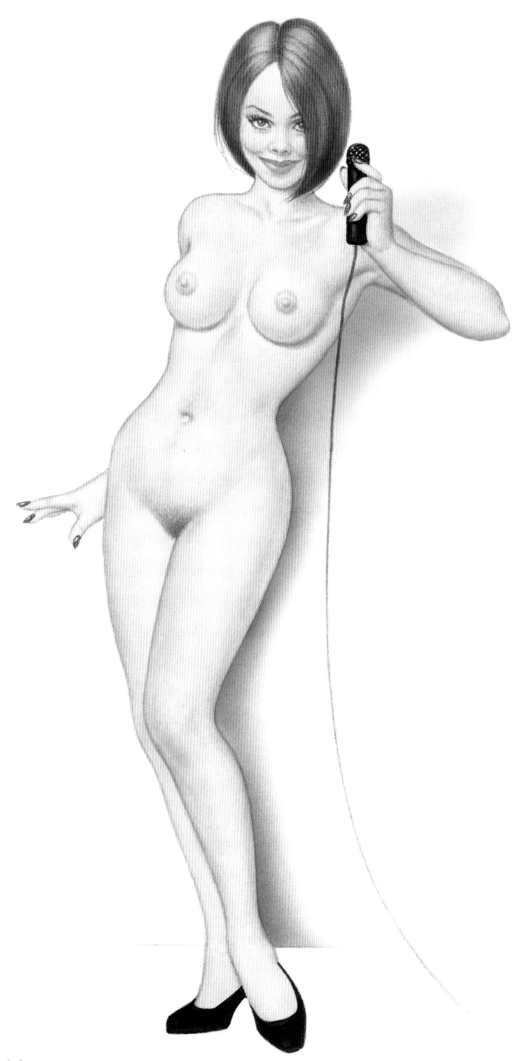

Taking Requests!

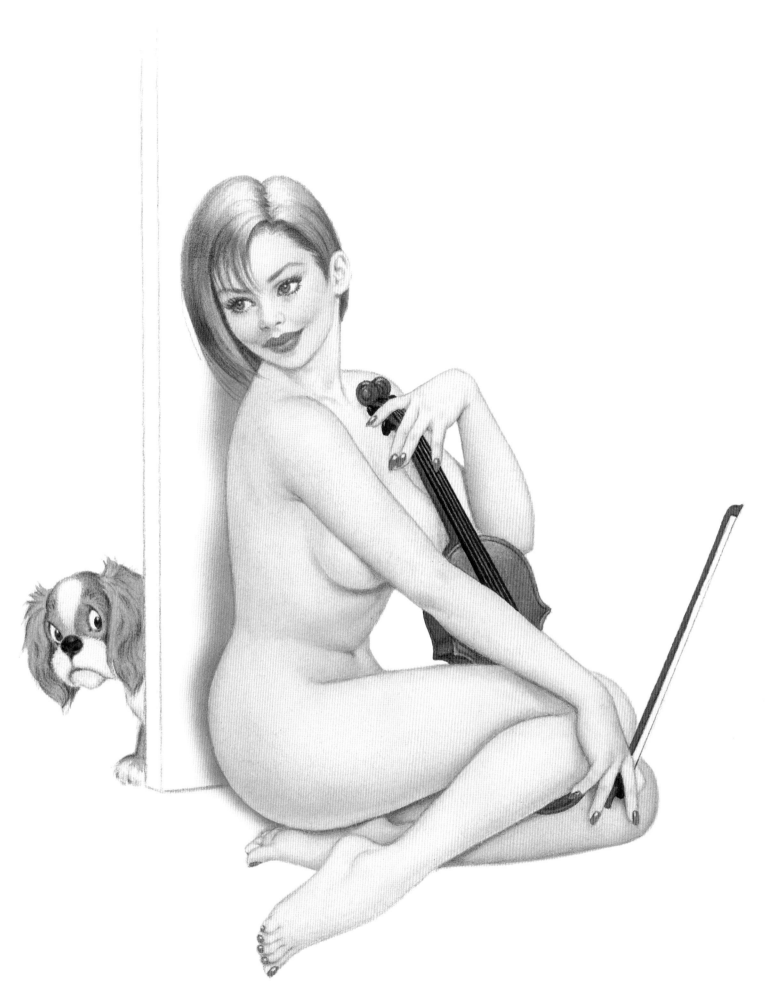

Okay, Lesson's Over!

Wish Me Luck

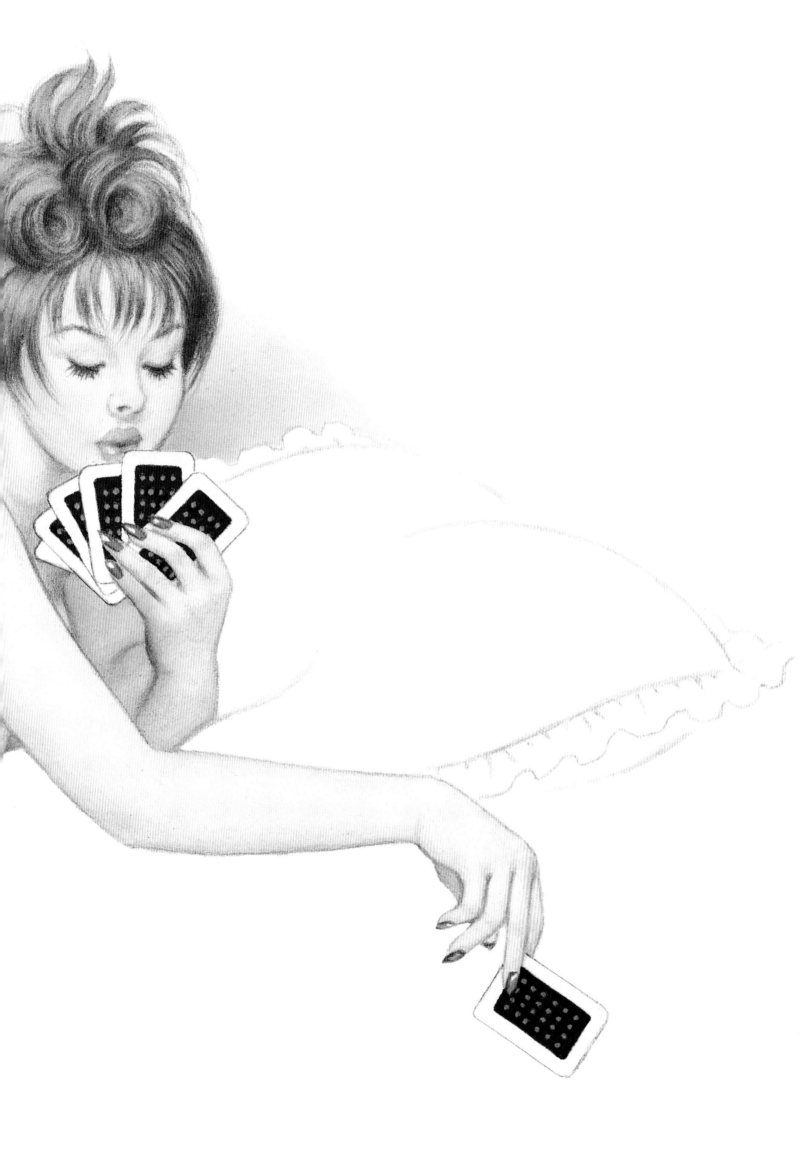

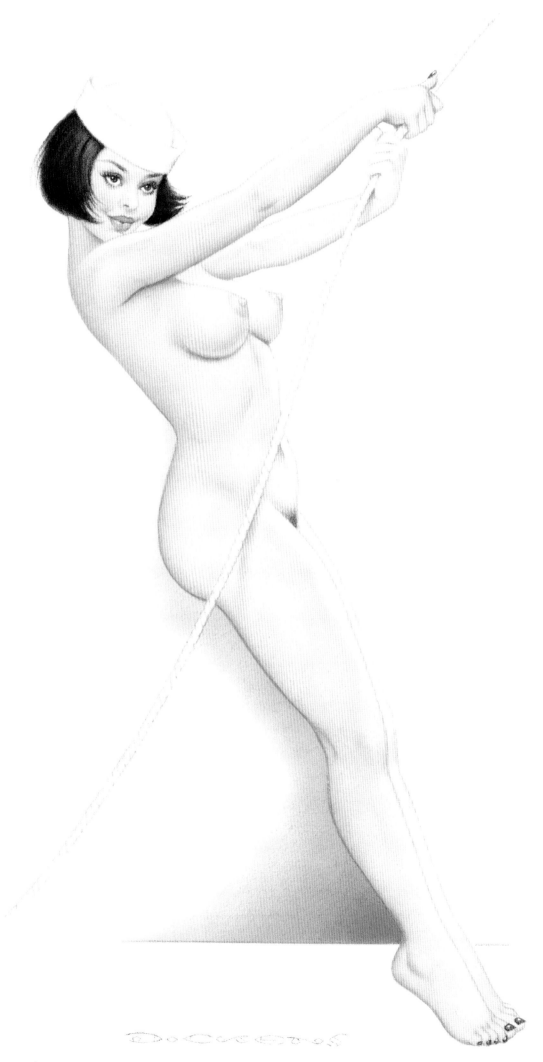

All Hands On Deck!

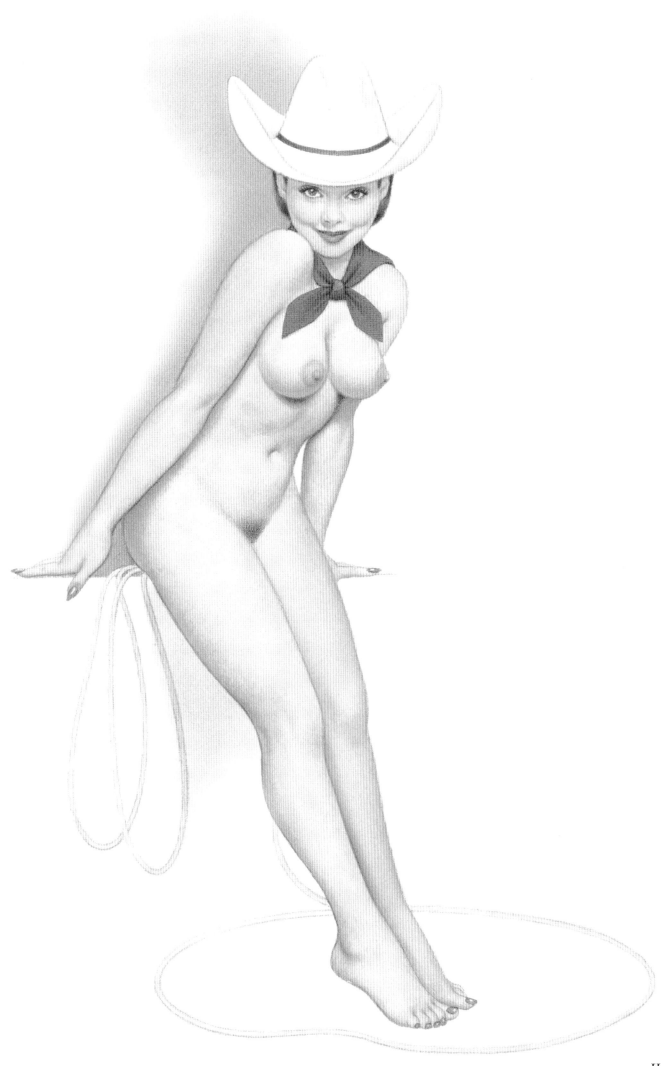

Howdy!

Siesta Fiesta

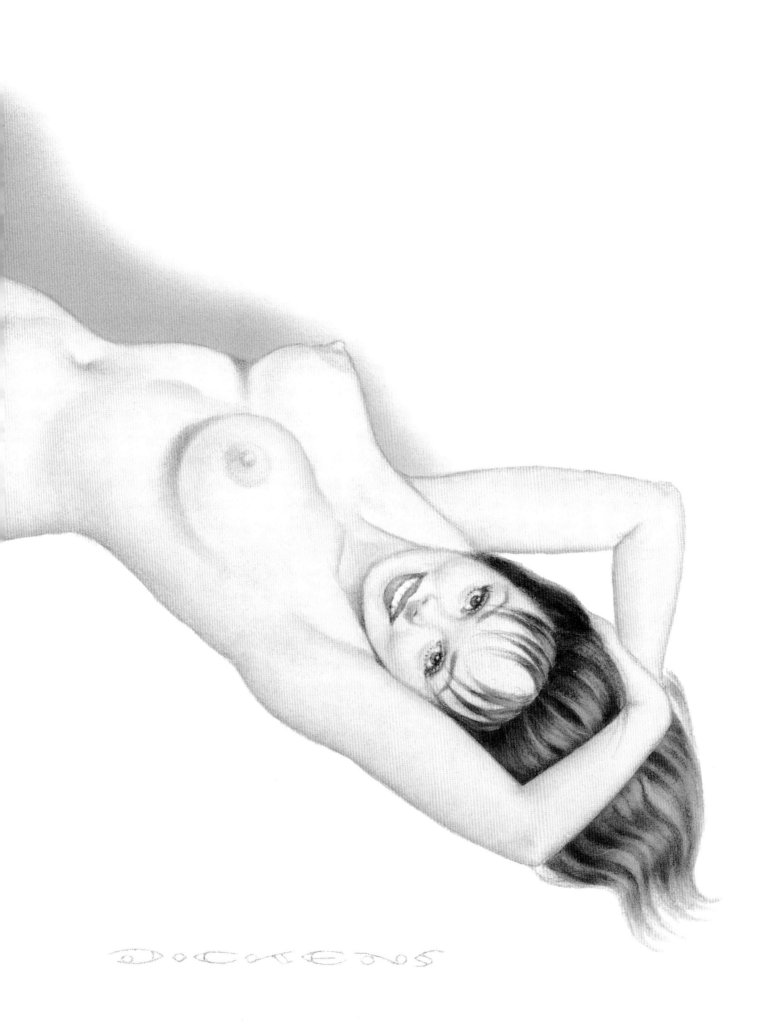

DICKENS

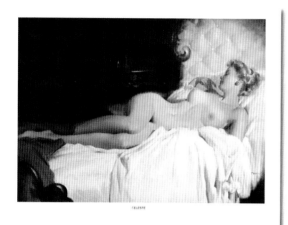
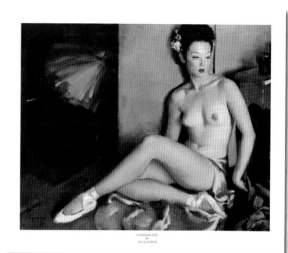
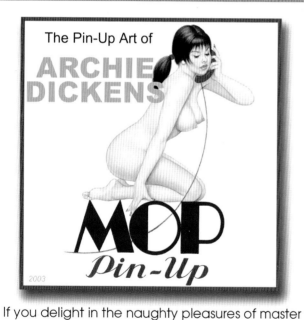
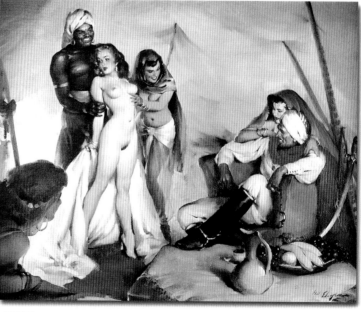